SPOTTER'S
WORLD

A Search and Find
for All Ages

Spotter's World

Published in November 2018 by Lonely Planet Global Ltd

CRN: 554153
ISBN: 978 1 78701 809 9

www.lonelyplanetkids.com
© Lonely Planet 2018

10 9 8 7 6 5 4 3 2 1

Printed in China

Publishing Director: Piers Pickard
Publisher: Hanna Otero
Art Director: Andy Mansfield
Commissioning Editor: Catharine Robertson
Designer: Tina García
Author and Editor: Kate Baker
Print Production: Lisa Ford, Nigel Longuet

Lonely Planet Offices

AUSTRALIA
The Malt Store, Level 3, 551 Swanston St,
Carlton, Victoria 3053
T: 03 8379 8000

IRELAND
Digital Depot, Roe Lane (off Thomas St), Digital Hub,
Dublin 8, D08 TCV4

USA
124 Linden St, Oakland, CA 94607
T: 510 250 6400

UK
240 Blackfriars Rd, London, SE1 8NW
T: 020 3771 5100

STAY IN TOUCH
lonelyplanet.com/contact

MIX
Paper from
responsible sources
FSC™ C021741

INSTRUCTIONS

 Get ready for possibly the world's hardest spotting adventure.

 With each turn of the page you'll be taken to a brand new destination – from a beautiful beach and vibrant festivals to bustling cities and markets. Each scene is crammed with hidden details: a teapot in a Moroccan souk; some goggles at Spain's messy Tomatina Festival; a ping-pong table in a Brazilian favela...

 We've picked out some items for you to spot on every page. Some are tucked away in the middle of a crowd of people, or in a pile of objects. Others may be painted on a sign, or printed on a t-shirt. So you'll need to search very carefully! Once you've discovered all of those, why not see what other things you can find?

HAPPY HUNTING EVERYONE!

*Answers can be found at the back of the book (no peeking).

BALLOON FESTIVAL, ALBUQUERQUE, USA

Every year, hundreds of hot-air balloons take to the skies during this nine-day ballooning extravaganza. The balloons come in all shapes and sizes, from alien rockets to giant pigs, and panda bears to doughnuts. Proof at last that pigs *can* fly!

See if you can spot…

2 green arrows

2 flowers

3 red caps

A green-and-white parasol

The number 6

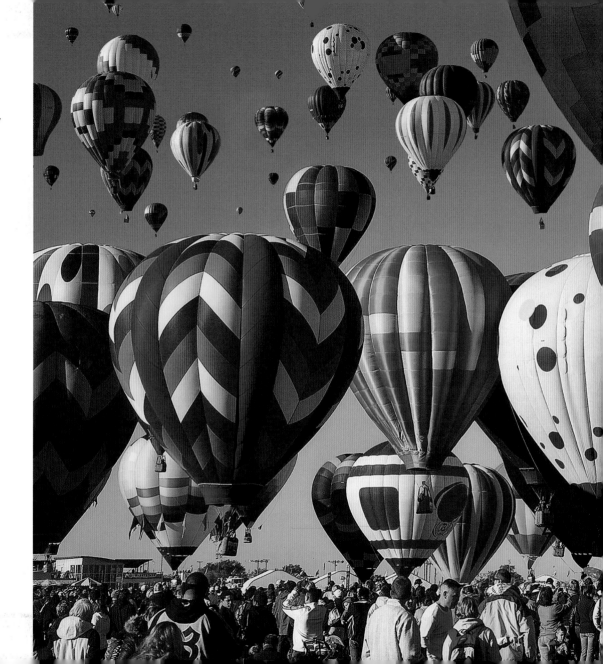

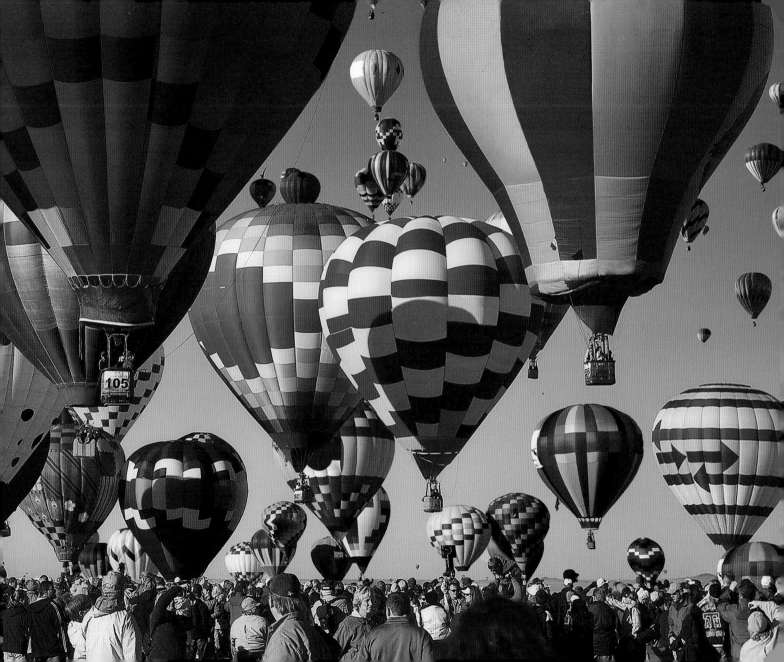

THE NATIONAL STADIUM, SINGAPORE

This crowd of Vietnamese soccer fans are cheering on their national team at the 2015 Southeast Asian Games. Look at the supporters' facial expressions – do you think their team is winning?

See if you can spot…

2 yellow hearts

3 blue inflatible sticks

5 conical hats

9 pairs of sunglasses

A plane

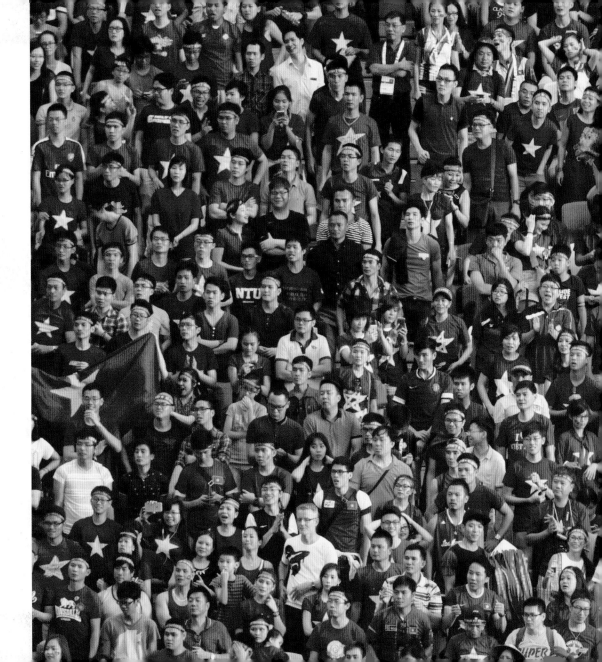

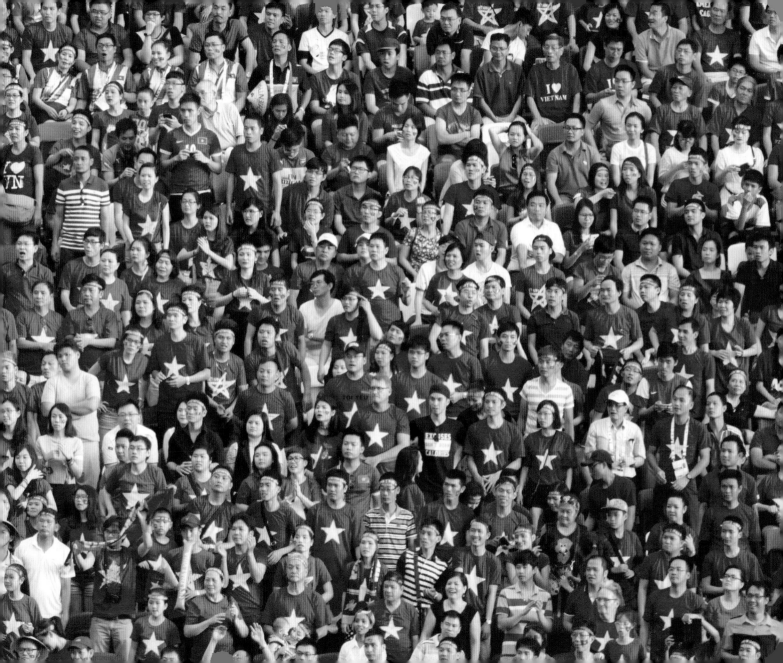

SHIBUYA CENTER-GAI, TOKYO, JAPAN

Crowded with people, shops, restaurants, and bright advertisements, Center-gai is one of the busiest and most popular streets in Tokyo. It's a great place to people watch, and you'll see some amazing new fashions!

See if you can spot…

9 basketballs

2 stop signs

An orange shoe

2 face masks

2 white umbrellas

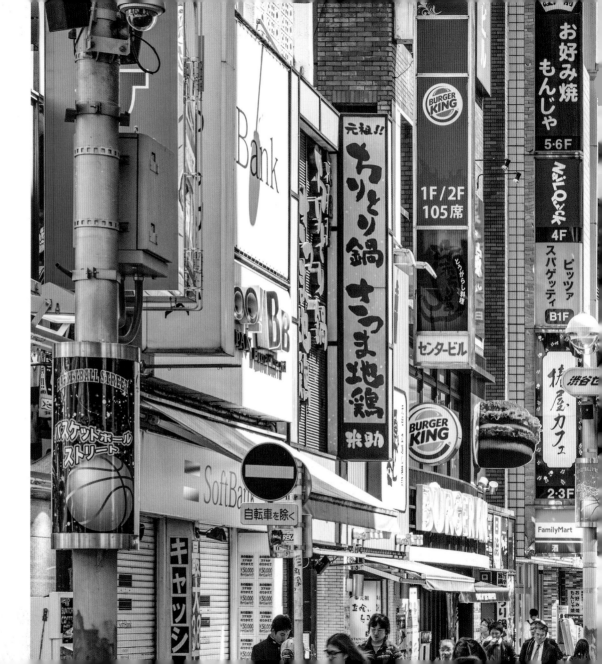

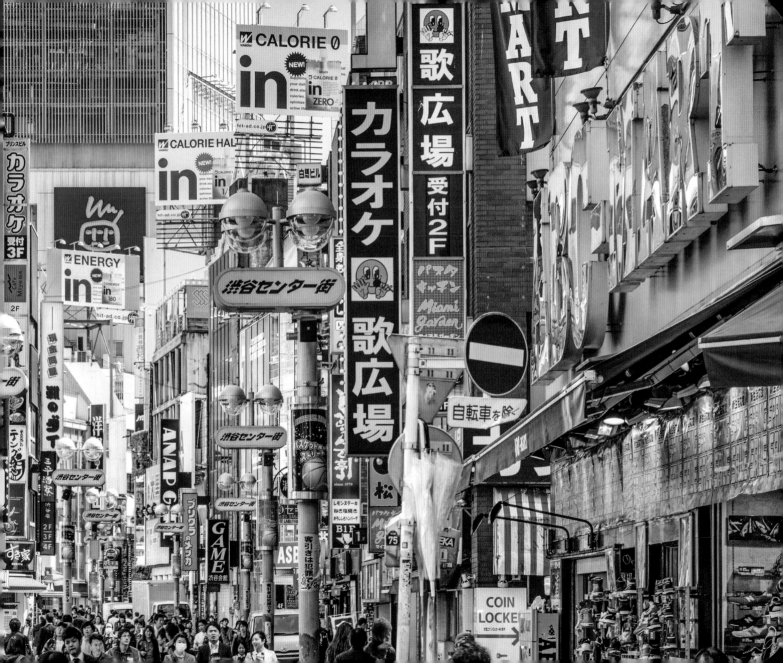

WRIGHTSVILLE BEACH, NORTH CAROLINA, USA

The sun's out, the surf's up – a perfect day to hang out at the beach. With beautiful white sand and clear blue waters, this stretch of coast is a great place for biking, fishing, swimming, paddling, surfing, and sailing. Or you can just throw down a towel, slap on some lotion and relax.

See if you can spot…

6 trash cans

A turtle

A white surfboard

A crescent moon

A bicycle

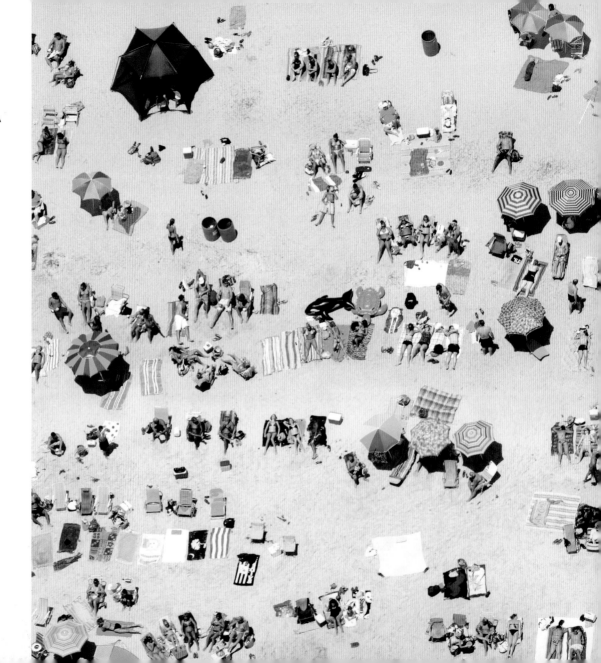

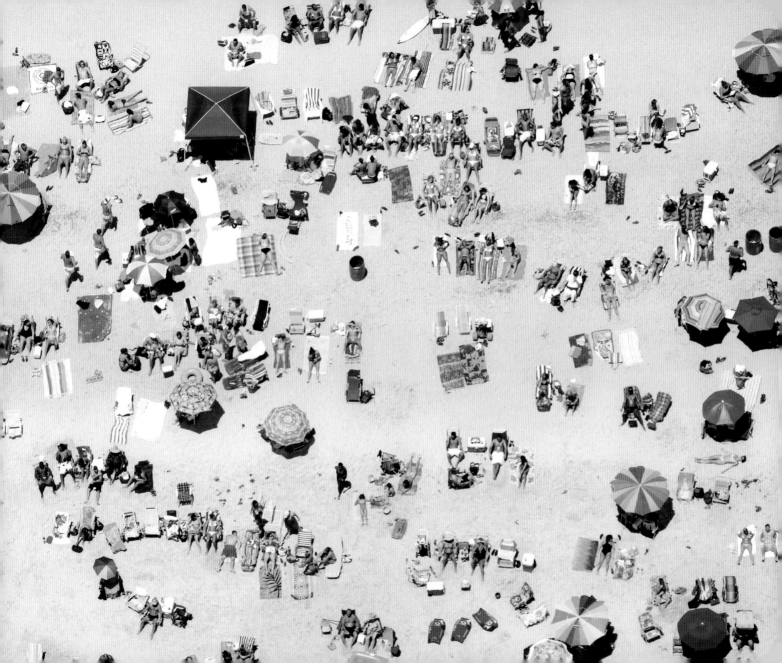

EL ENCANTS VELLS MARKET, BARCELONA, SPAIN

This huge flea market in Barcelona is one of the oldest markets in Europe – it's been around since the 14th century! With everything from antique furniture and toys to second-hand clothes and vintage vinyl on sale here, who knows what treasures you might find.

See if you can spot…

A green purse

A wall clock

A pair of headphones

A sword

A red pepper

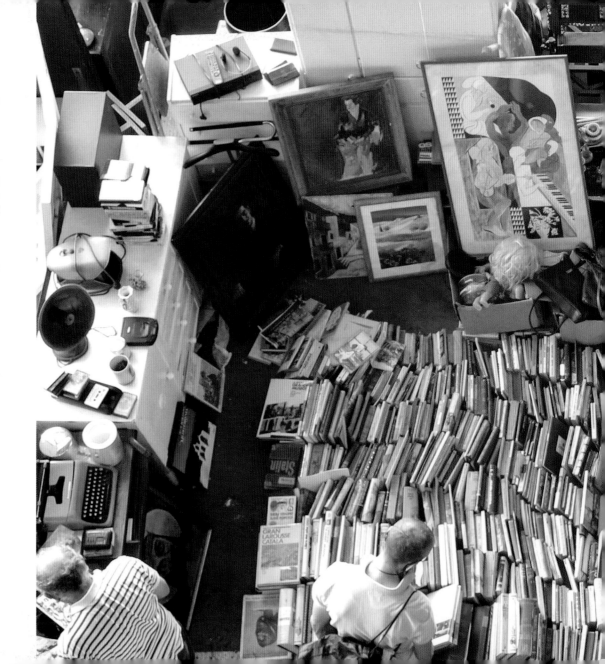

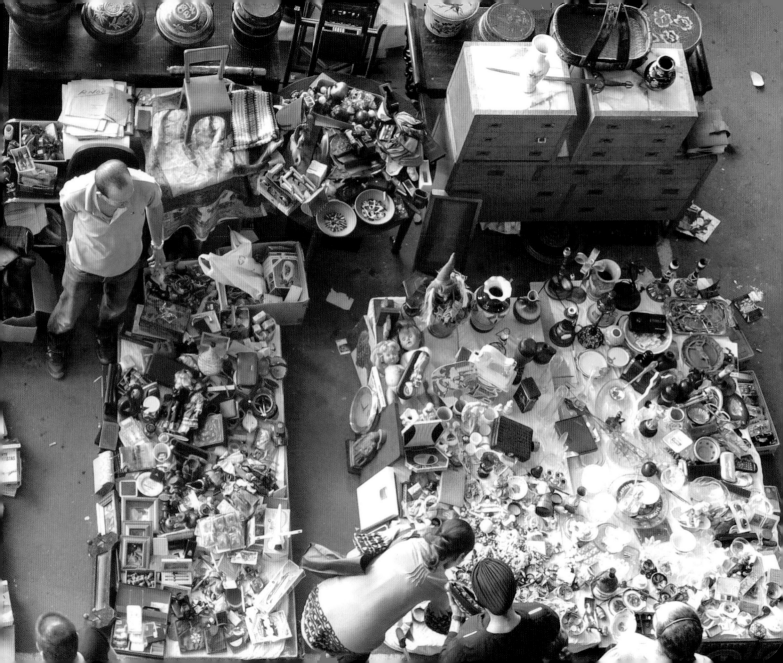

HO CHI MINH CITY, VIETNAM

It's rush hour in Ho Chi Minh City, and the streets are packed with motorcyclists. Motorbikes are the most popular way to get around, and there are no limits on what you can carry. You'll often see motorcyclists hauling animals, furniture, or several family members!

See if you can spot…

A red star

A British flag

3 bicycles

FB

The letters 'FB'

Purple gloves

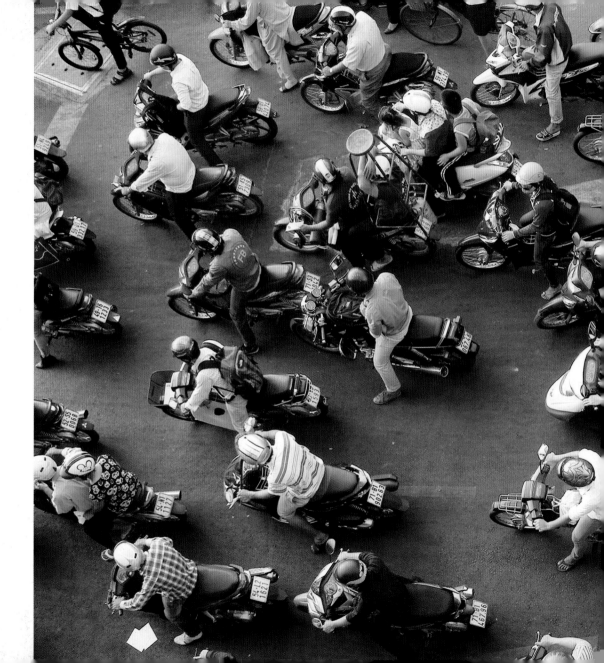

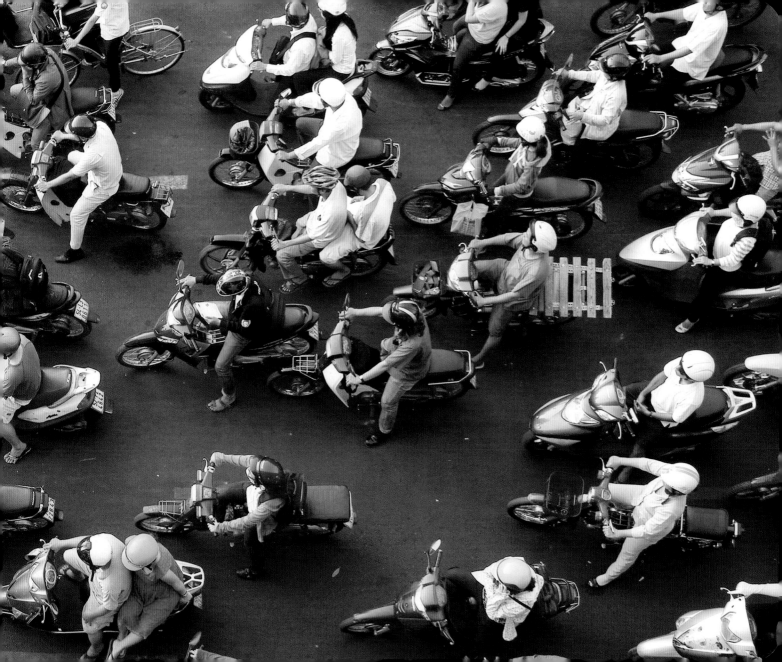

GOVARDHAN PUJA FESTIVAL, KOLKATA, INDIA

This holy festival marks the victory of Krishna (the Hindu god of love) over Indra (the god of rain). Huge piles of festival food are displayed at temples and blessed rice is thrown into the streets to be caught by crowds of worshippers.

See if you can spot...

A blue-and-black bag

5 umbrellas

An orange bow

2 checked shirts

3 black moustaches

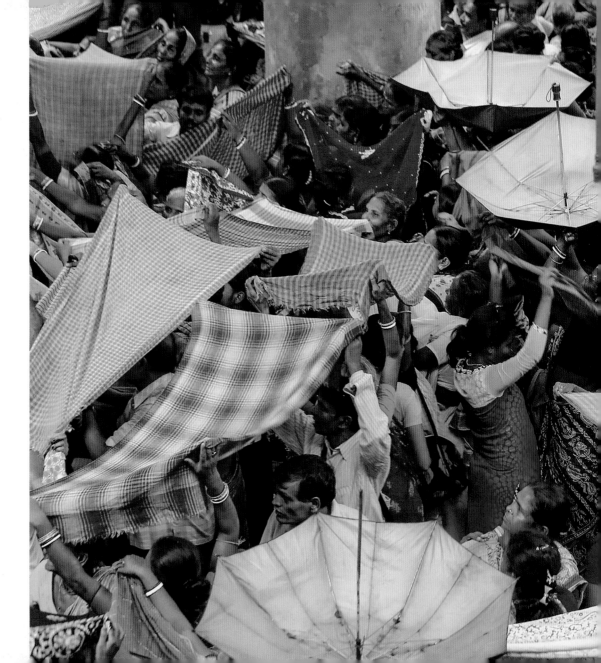

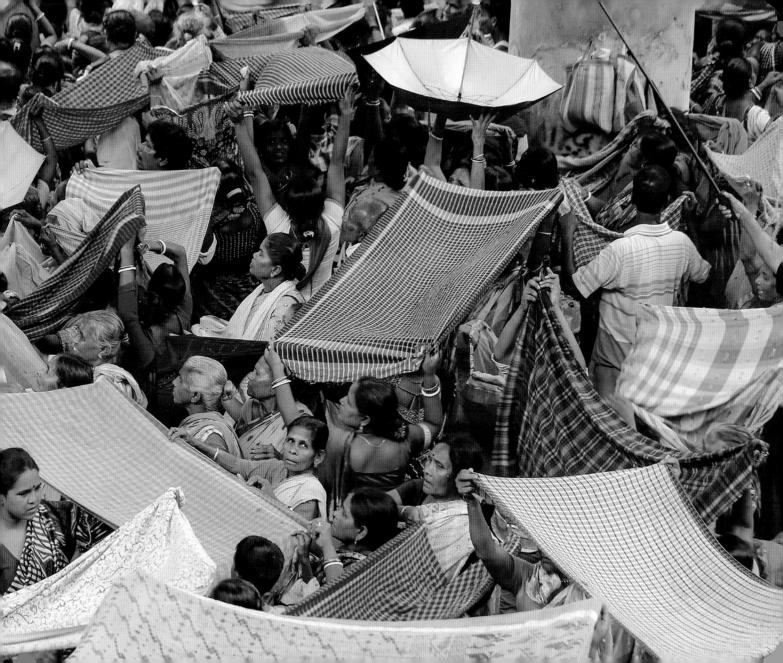

ROYAL ASCOT, BERKSHIRE, UK

It's Ladies Day at Royal Ascot – one of the most glamorous events in the horseracing calendar. The crowds are awaiting the arrival of Her Majesty The Queen, who is driven to the course each day in a horse-drawn carriage. Who do you think should win the fanciest-hat competition?

See if you can spot…

8 grey top hats

2 pairs of binoculars

3 yellow flowers

A glass

2 open books

20

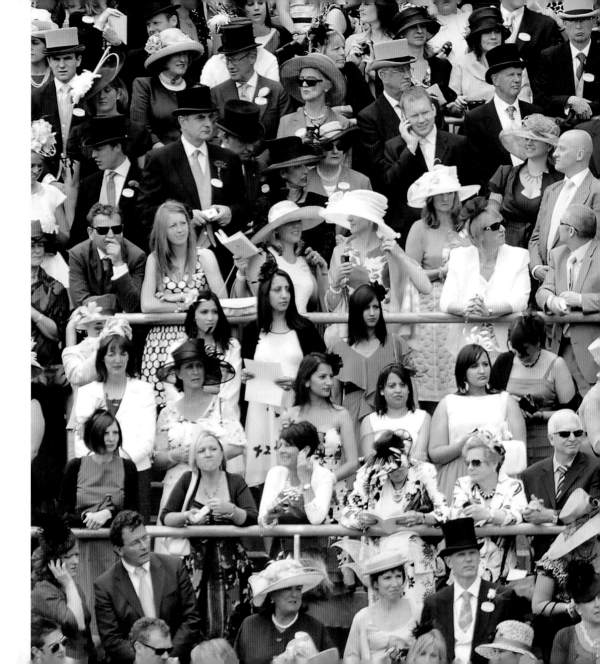

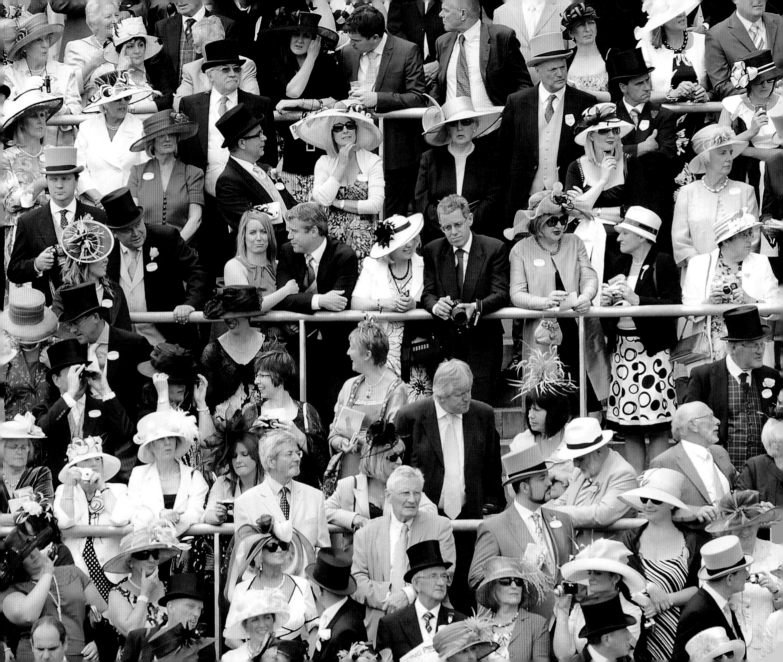

SHIBUYA CROSSING, TOKYO, JAPAN

This famous intersection outside Shibuya Station is one of the busiest in the world. When the lights turn red, the traffic stops, and hundreds of pedestrians spill onto the zebra crossings from all directions. The aim is to get to the other side without bumping into anyone!

See if you can spot…

A blue car

150

The number 150

A buggy

A coral reef

3 red traffic lights

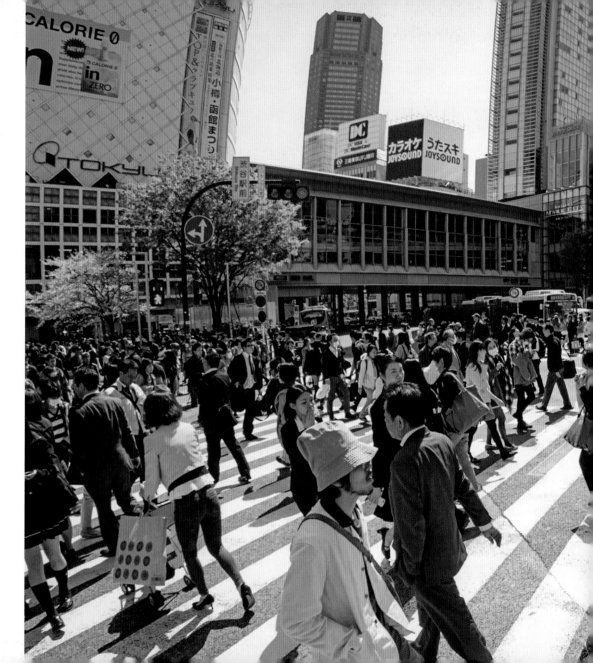

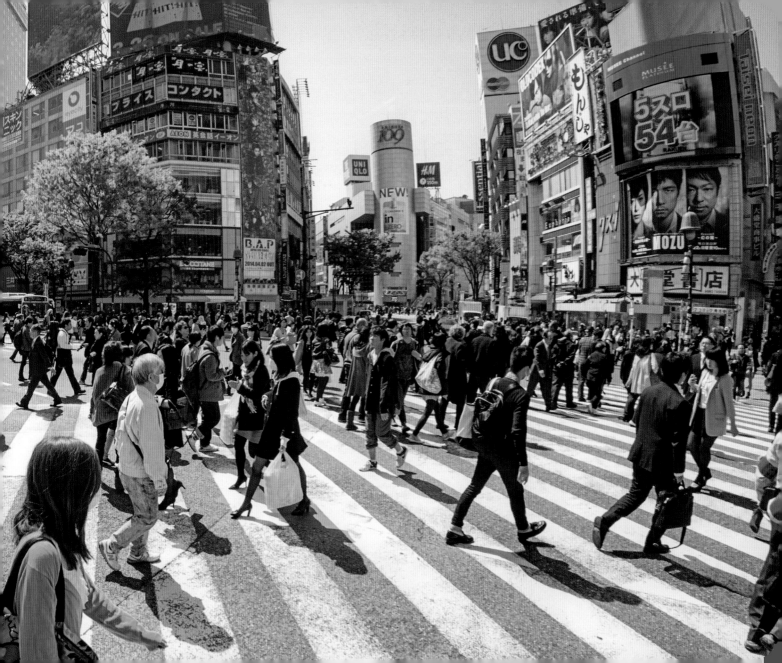

FLOATING MARKET, AMPHAWA, THAILAND

Every weekend, the canal at Amphawa near Bangkok brims with rickety paddleboats piled high with edible treats. Local specialties include fresh crab, cooked right there on floating kitchens, and exotic fruit with strange sounding names like rambutans and pomelos.

See if you can spot...

2 plain red umbrellas

A cowboy hat

2 bicycle wheels

A blue basket

A pink towel

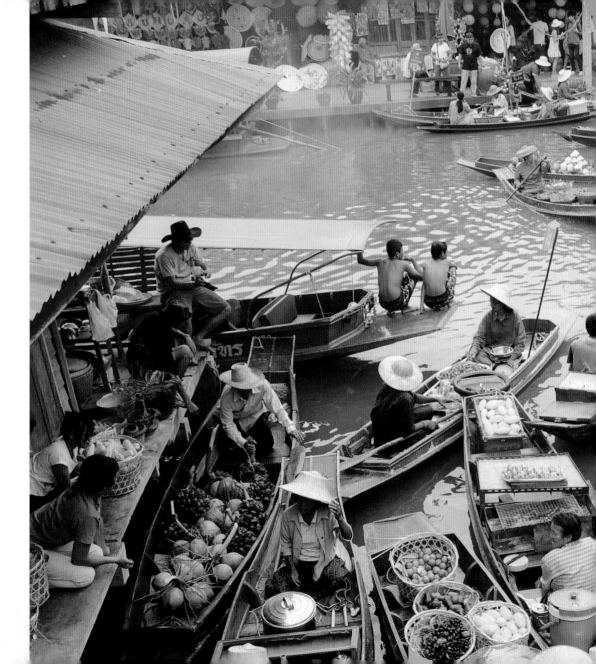

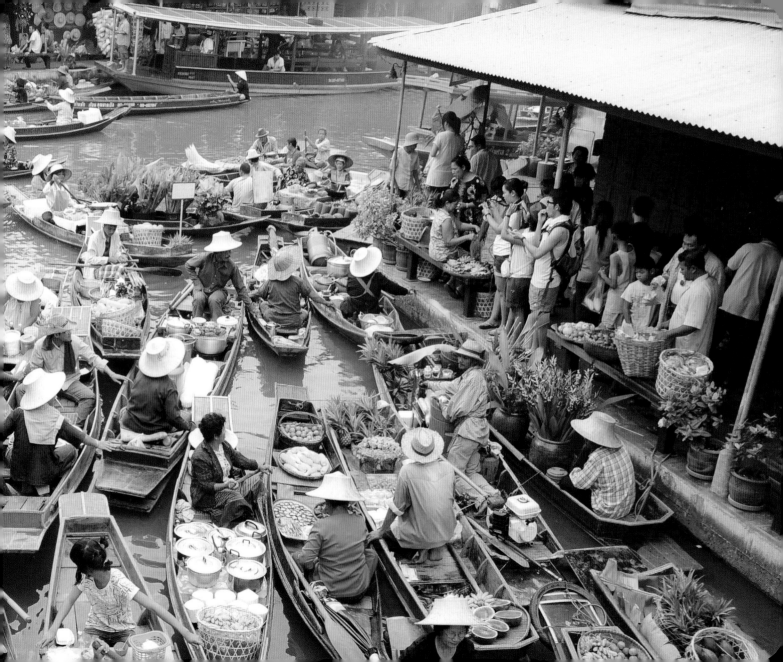

NORDIC WORLD SKI CHAMPIONSHIPS, LAHTI, FINLAND

Events at this winter sports competition include cross-country skiing, ski jumping, and the Nordic combined, where competitors first jump, then ski! Spectators need to wrap up in their warmest coats and bobble hats – temperatures can reach a toe-numbing -8°C (19°F).

See if you can spot…

The letter N

3 blue balloons

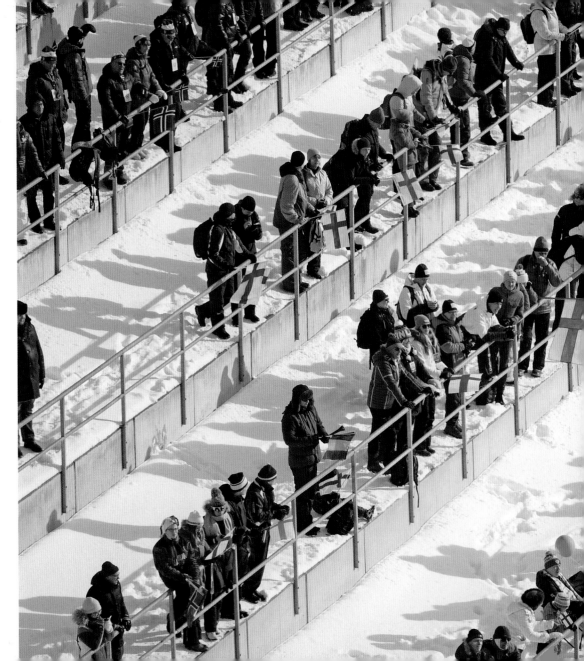

4 Norwegian flags

A yellow coat

2 stools

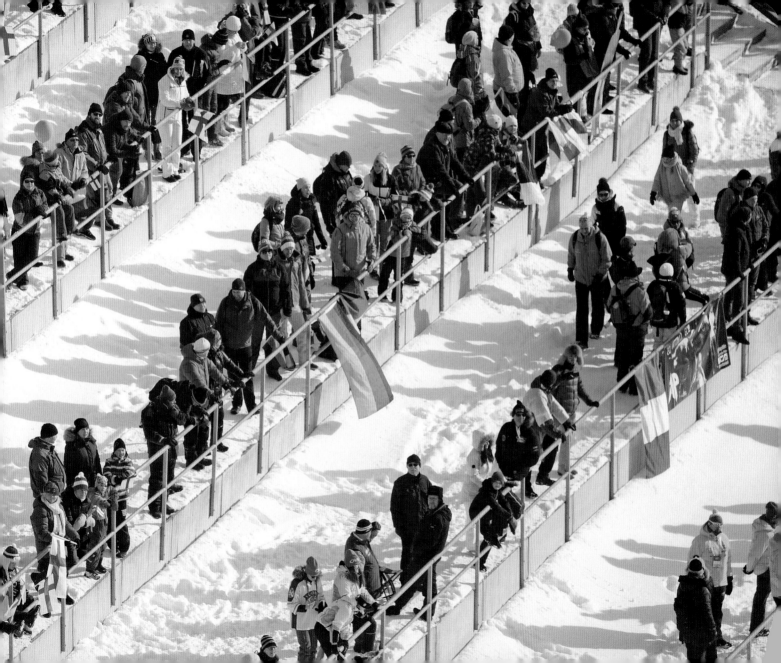

SOUK DISTRICT, MARRAKESH, MOROCCO

Traders have been selling their wares in the winding alleyways of Marrakesh for thousands of years. There are all sorts of treasures to be found, from candlesticks and copper pots to spices, silks, and sequined slippers. There are lots of bargains to be had, if you know how to haggle!

See if you can spot…

A teapot

A giraffe

A pink star

3 turtles

A blue bracelet

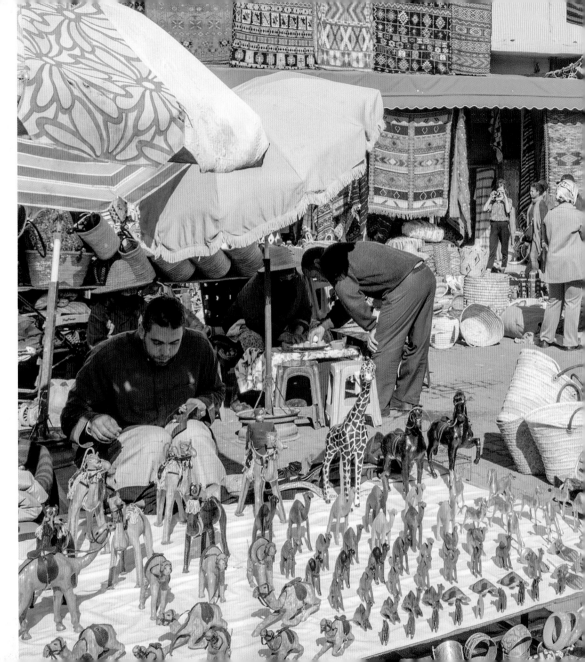

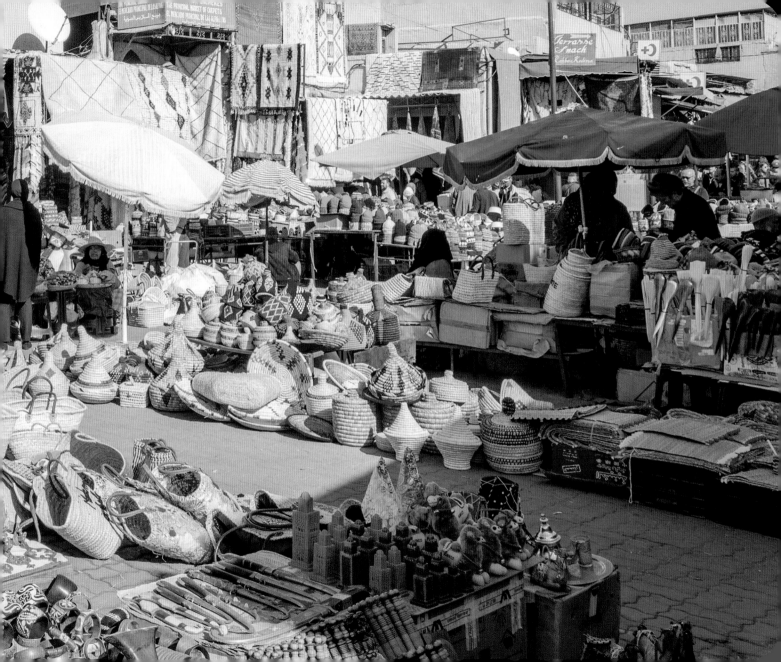

TOMATINA FESTIVAL, BUÑOL, SPAIN

Each August, thousands of people gather in the narrow streets of Buñol for Spain's messiest festival. Around 120 tons of tomatoes are then dumped into the crowds, kicking off the world's biggest tomato-throwing fight. There's one important rule to remember: tomatoes must be squished first, then thrown.

See if you can spot...

A wig

A truck

2 pairs of pink goggles

SP

The letters SP

A police hat

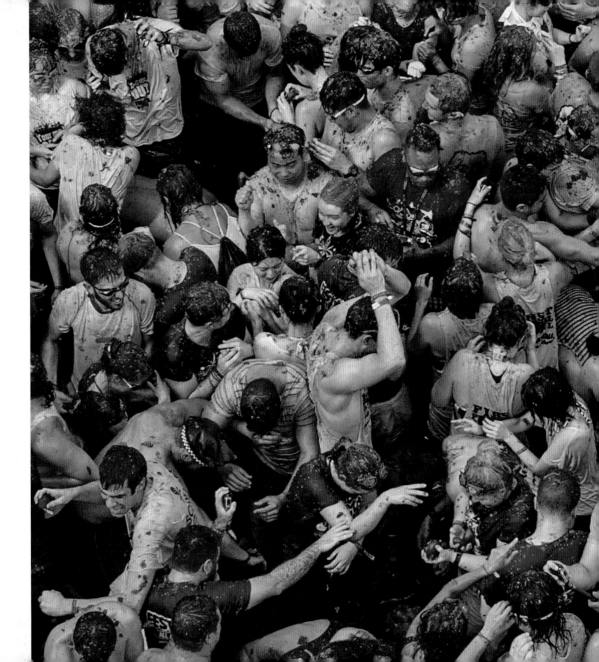

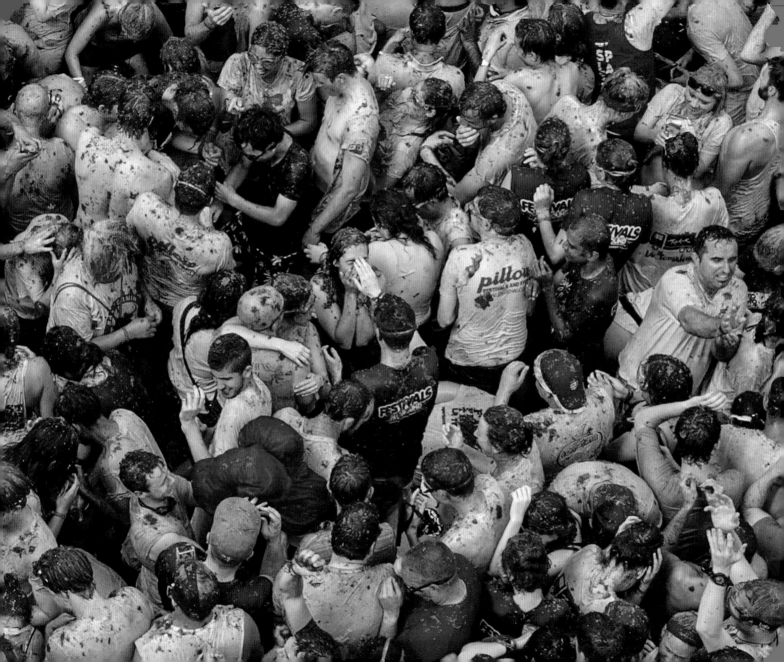

TOUR OF QATAR, DOHA, QATAR

It's the final stage of the grueling cycle tour of Qatar, and the pack is pedaling it out for the 'gold jersey' – the prize awarded to the overall winner. In the background you can see the city's spectacular skyline filled with futuristic skyscrapers – some of the tallest buildings in the world.

See if you can spot…

5 water bottles

A bandage

2 green glasses

An orange bicycle

34

The number 34

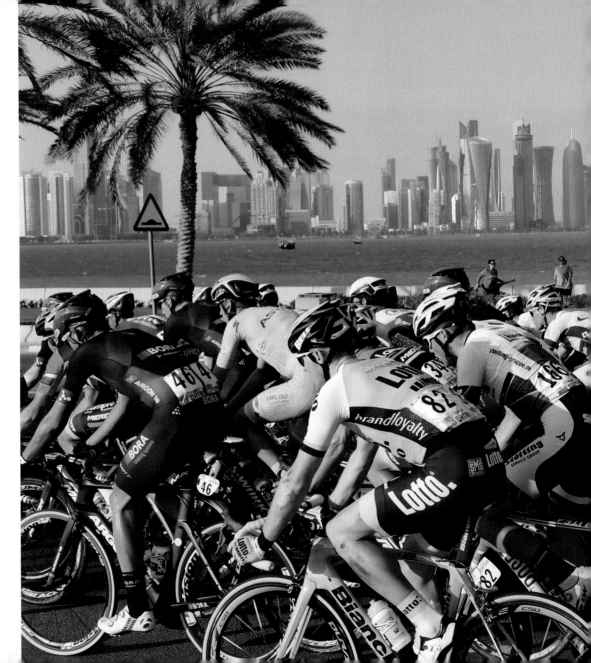

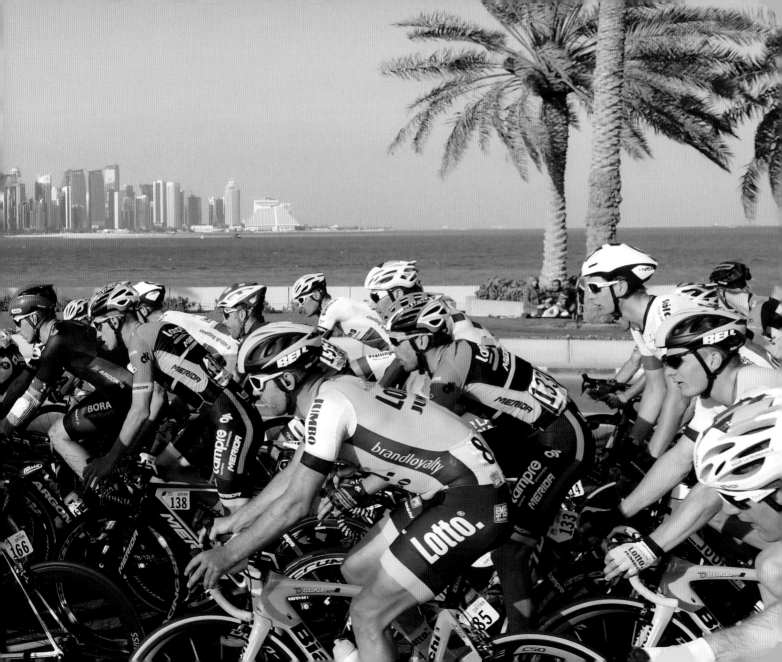

DAYING DEAD SEA RESORT, SUINING, CHINA

As temperatures soar, swimmers grab their rubber rings and flock in their thousands to cool off in this giant indoor waterpark. It's so jam-packed that most people just bob along in their inflatables, while cheerleaders perform on platforms by the side of the pool!

See if you can spot...

2 flowers

babies

The word 'babies'

13 floats with stars

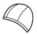

4 patterned swimming hats

A green-and-blue t-shirt

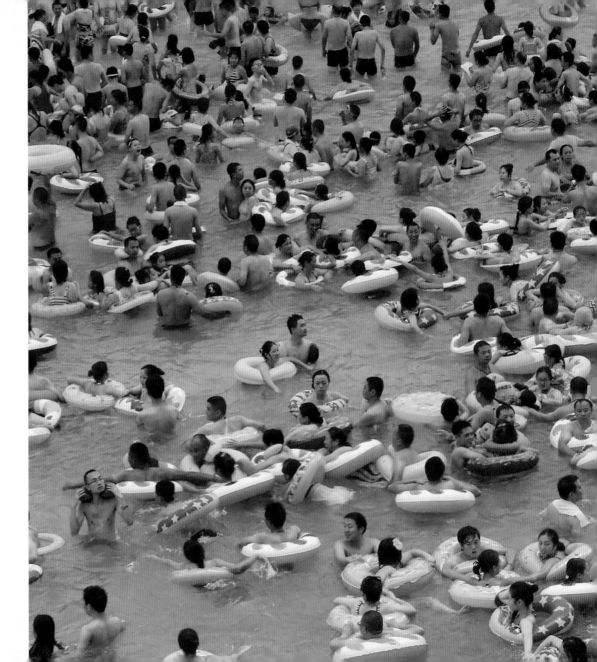

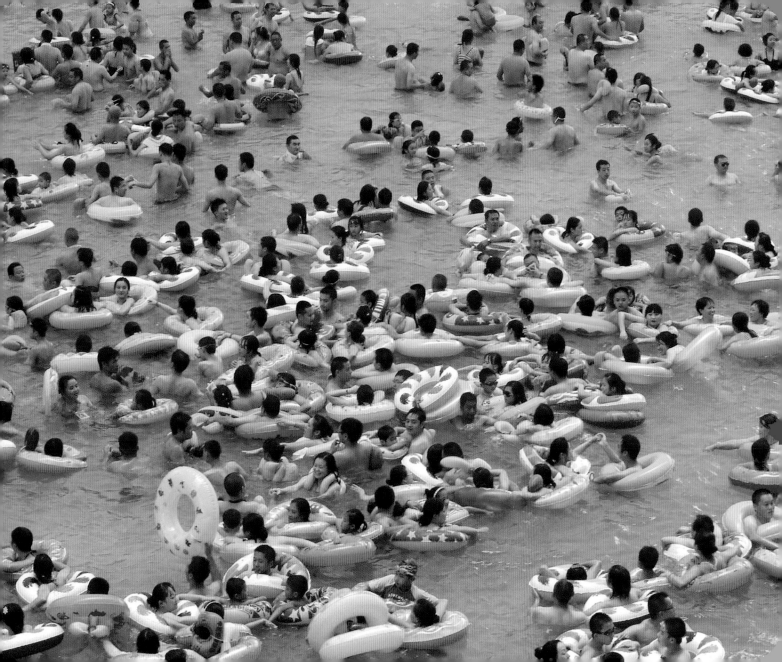

SOUVENIR SHOPS, CUZCO, PERU

The markets of Cuzco are crammed with amazing crafts that have been handmade using ancient techniques. There are brightly patterned blankets stacked high in neat piles, jumpers and hats made from super-soft alpaca wool, and paintings of Machu Picchu – a mysterious Inca city that lay hidden in the Andes Mountains for around 400 years.

See if you can spot…

8 cats

A bell

2 butterflies

3 blue vicuñas

aquí
The word 'aquí' (meaning 'here')

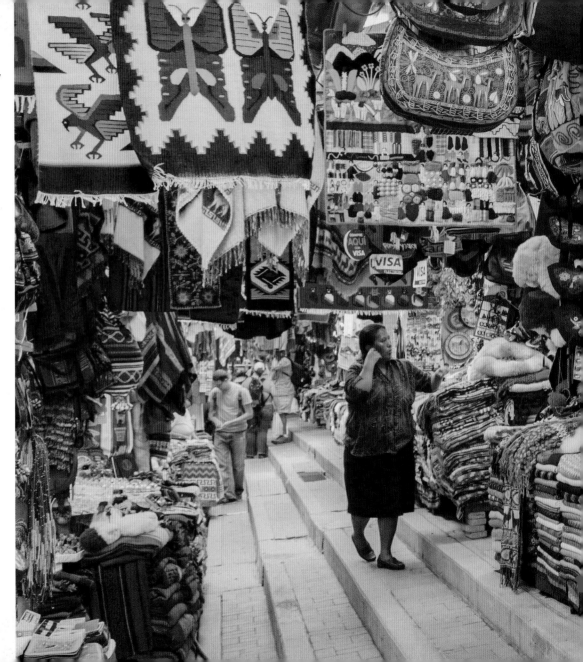

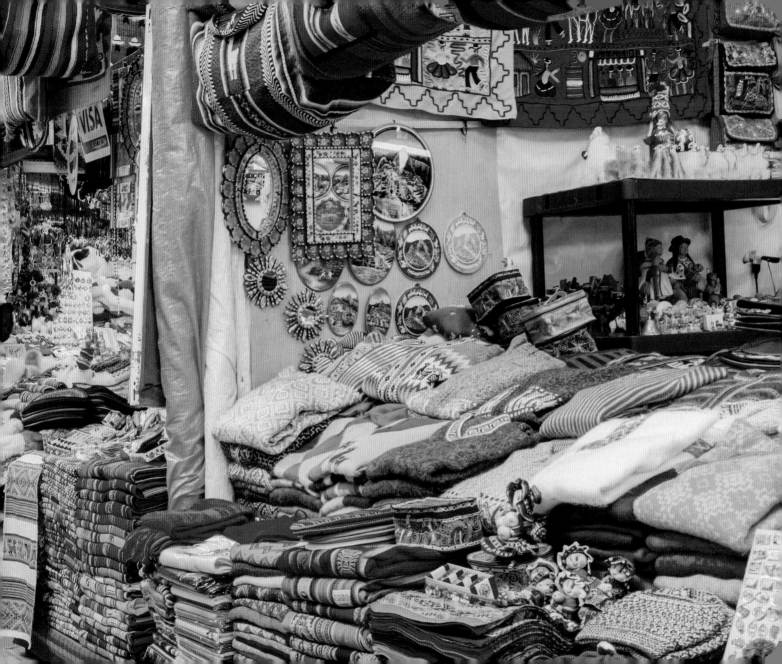

CARNIVAL, VENICE, ITALY

On the first day of Venice's famous festival, partygoers take to the streets and canals disguised in costumes and masks. Many come dressed as 18th-century lords or ladies with enormous wigs, as medieval court jesters, or as plague doctors with long beaked noses. What costume would you choose?

See if you can spot...

A pair of devil horns

GONDOLA

The word 'gondola'

An orange security vest

A wizard's hat

A plague doctor's mask

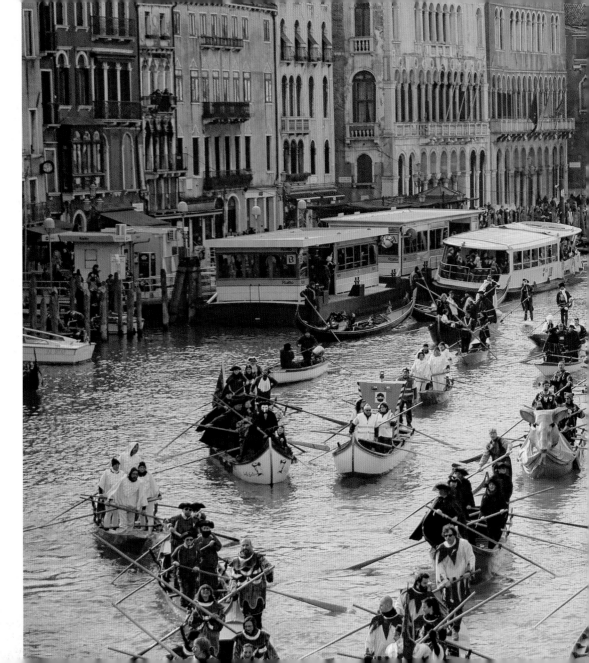

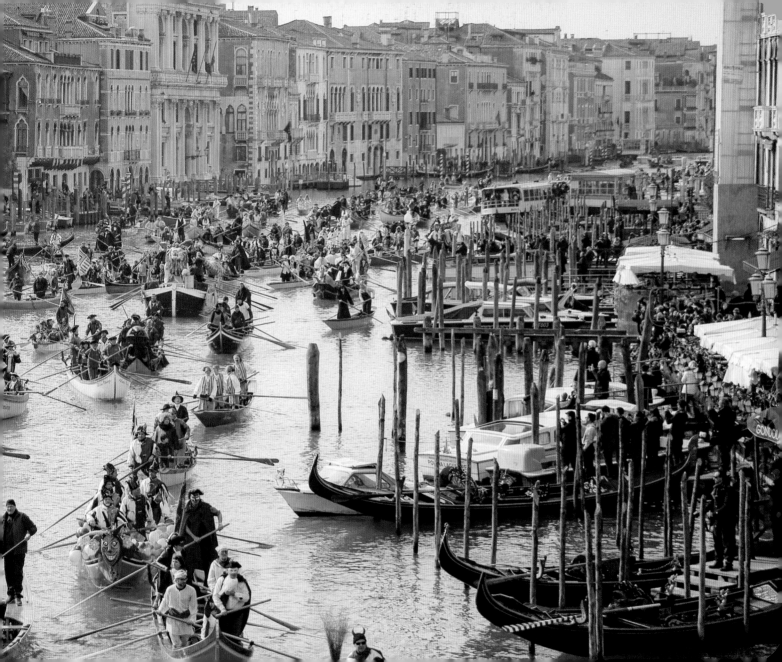

APARTMENT BUILDING, PHNOM PENH, CAMBODIA

This apartment block in Cambodia's busy capital city is home to thousands of people of all ages, including dancers, musicians, artists, sculptors, shopkeepers, and teachers. The weather here is nice and warm all year round – perfect for drying your washing!

See if you can spot…

A blue chair

67

The number 67

A white stool

2 pink flowers

A pair of black jeans

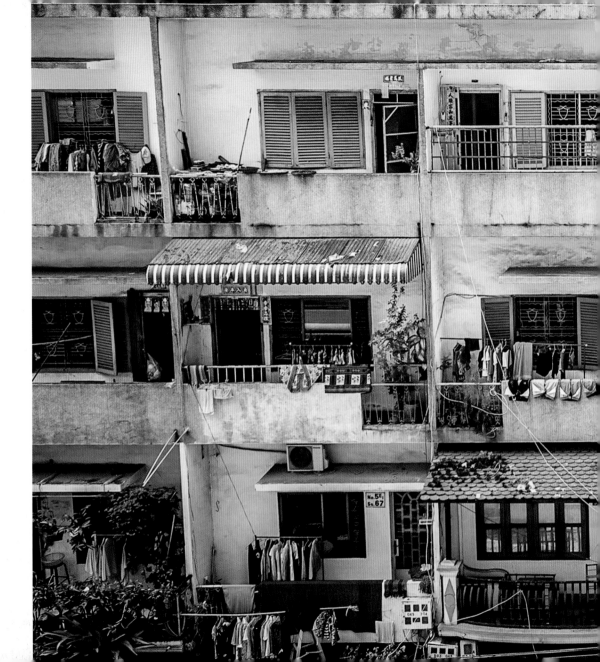

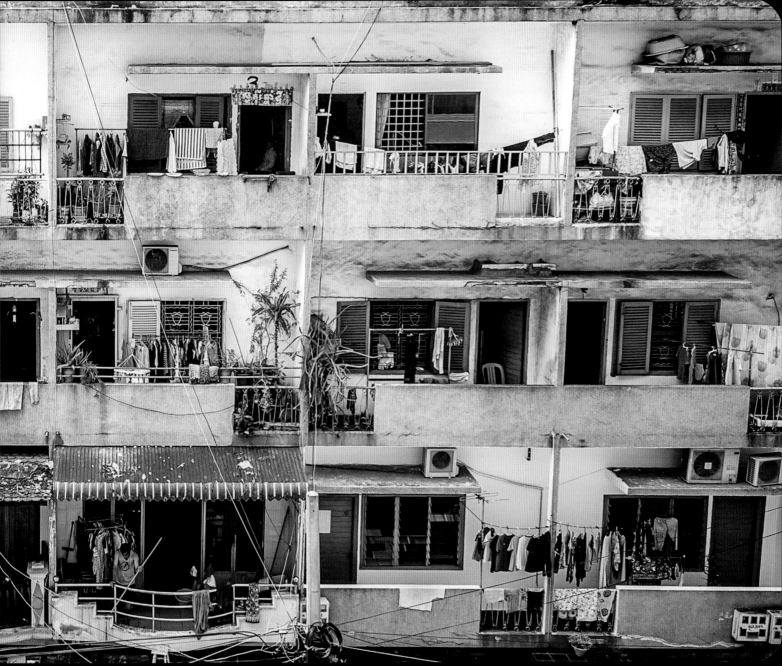

MAKOLA MARKET, ACCRA, GHANA

You'll find all kinds of things on sale in the markets of Ghana's capital city. There are wooden carvings, woven baskets, beads, bags, sandals, and rugs. You can buy pots and pans, canned meat, dried fish, fresh fruit ... then carry it all home on top of your head!

See if you can spot...

3 blue flip-flops

A pink bowl

star

The word 'star'

A purple bag

2 steam engines

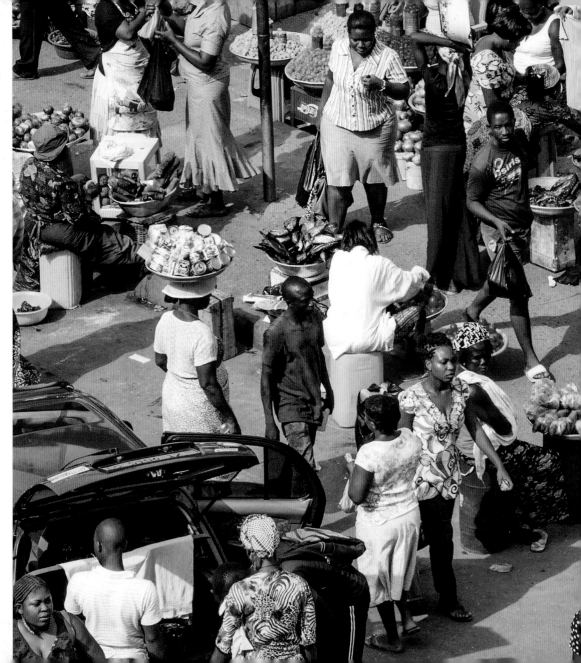

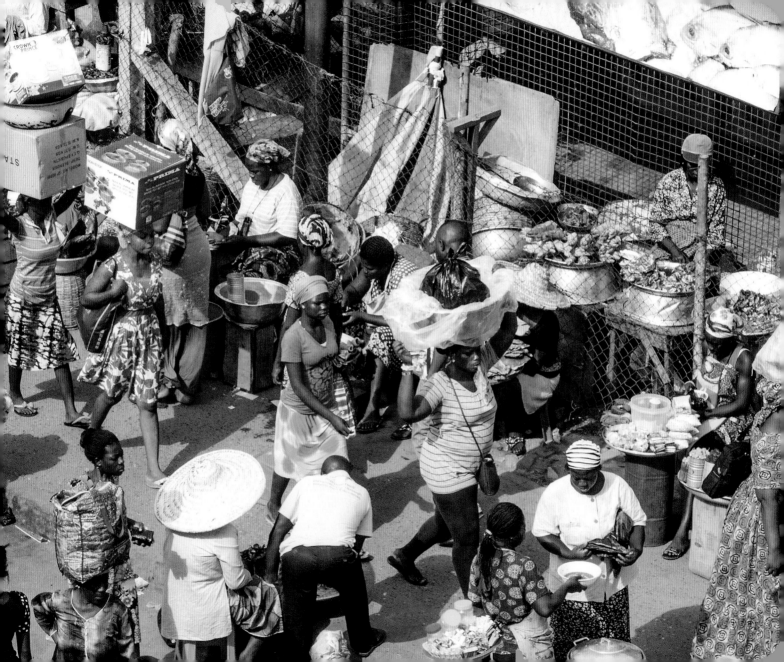

LANTERN FESTIVAL, GUANGZHOU, CHINA

This 2,000-year-old festival takes place each year to mark the end of the Chinese New Year celebrations. People make masks, sing songs, and as night falls, thousands of beautiful lanterns are released into the sky to bring good luck for the year ahead.

See if you can spot...

2 butterflies

A pink shoelace

A yellow chair

A hand fan

3

The number 3

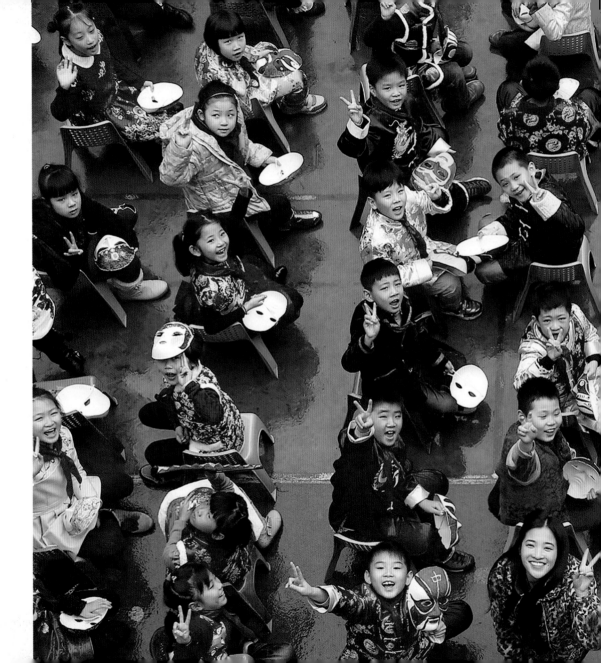

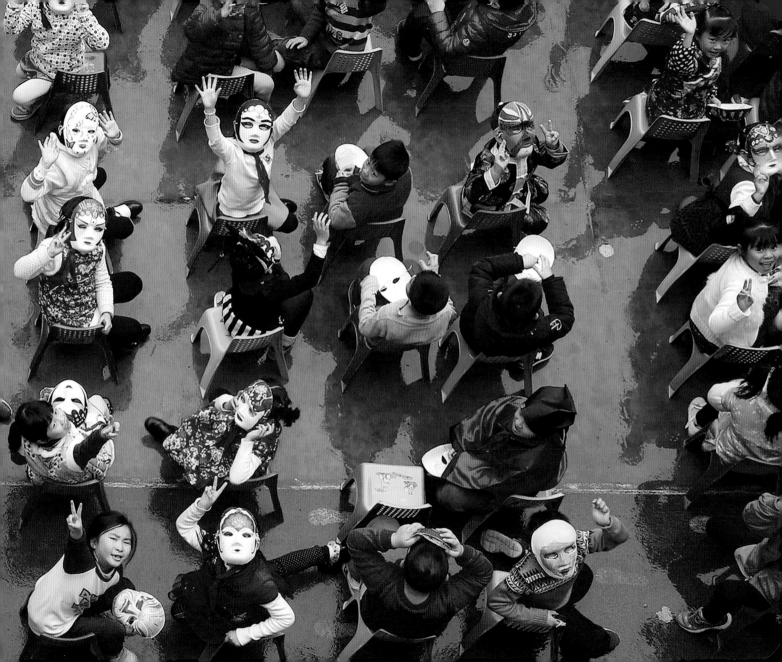

GHATS, VARANASI, INDIA

It's early morning in Varanasi, and crowds are gathered near the holy ghats. Built by kings hundreds of years ago, the ghats are giant ceremonial steps that lead down to the River Ganges. It is a very sacred place, and people come here to wash away sins and to cremate their loved ones.

See if you can spot...

3 matching chairs

A red flag

A pair of blue shoes

2 cameras

11

The number 11

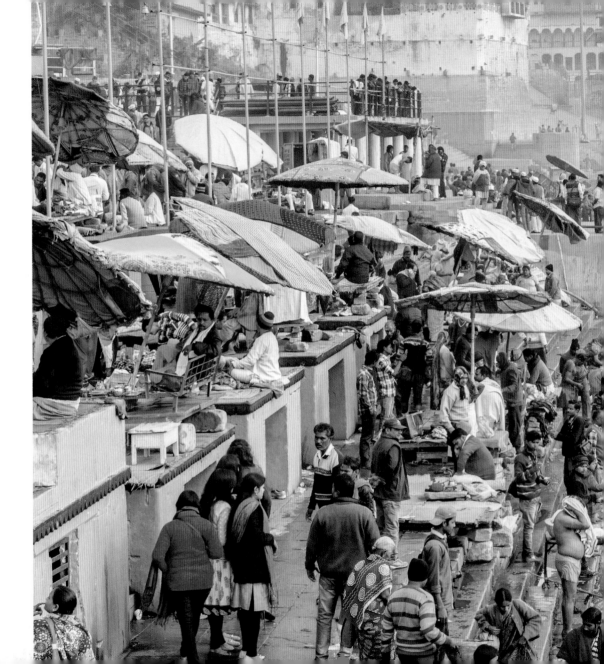

CAMPSITE, MUNICH, GERMANY

These happy campers are here for the world's largest juggling convention. Held in a different city each year, there are juggling workshops, competitions, and a huge juggling parade. If juggling doesn't take your fancy, there are unicyclists, stilt walkers, fire twirlers, and hula hoopers, too.

See if you can spot...

A palm tree

An orange stool

A white bag

3 red blankets

A cart

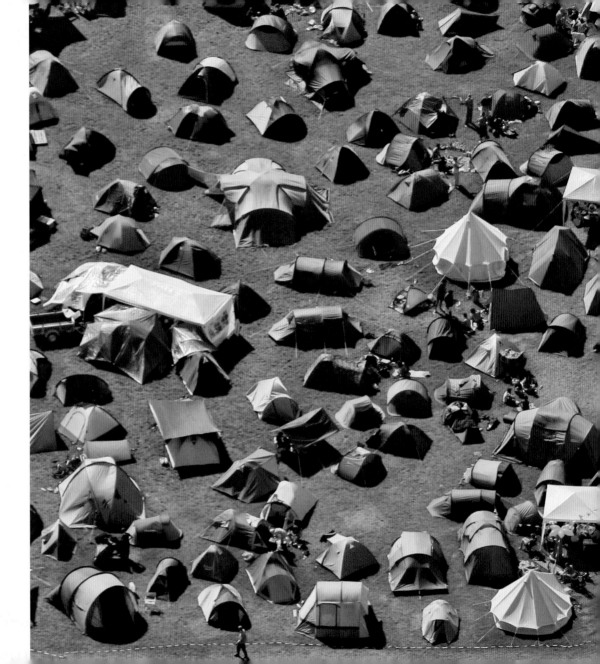

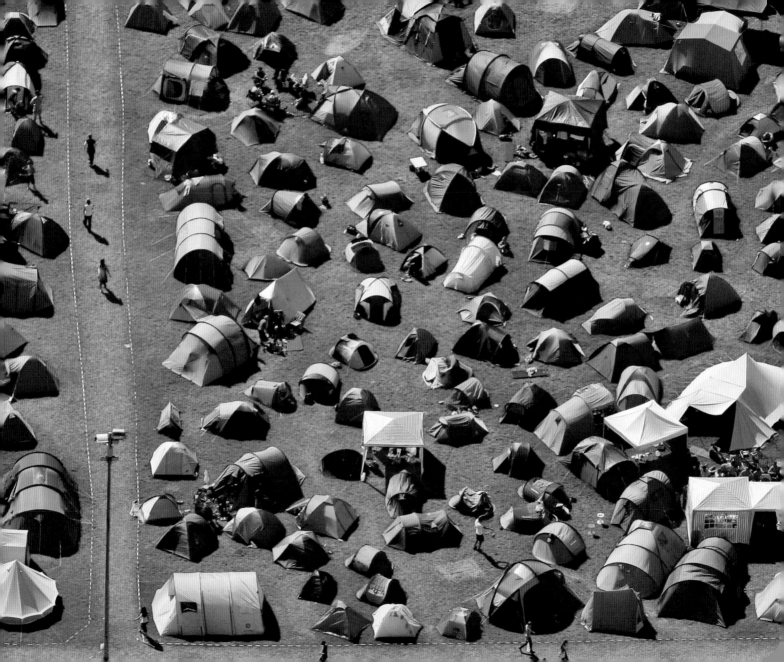

ROCINHA FAVELA, RIO DE JANEIRO, BRAZIL

Perched in the steep hills on the edge of Rio is the densely packed neighbourhood of Rocinha. It's estimated that more than 100,000 people live here, including many of the musicians and dancers who take part in the famous Rio Carnival each year.

See if you can spot…

A ladder

A red chair

5 red curtains

A ping-pong table

3 white tables

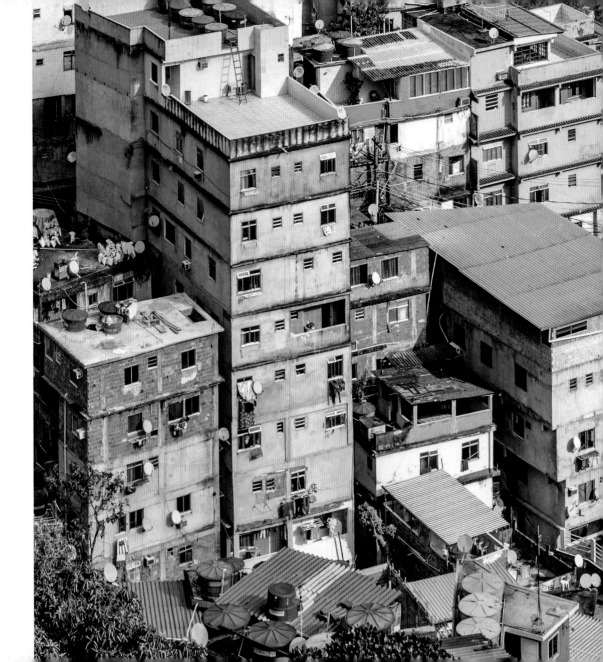

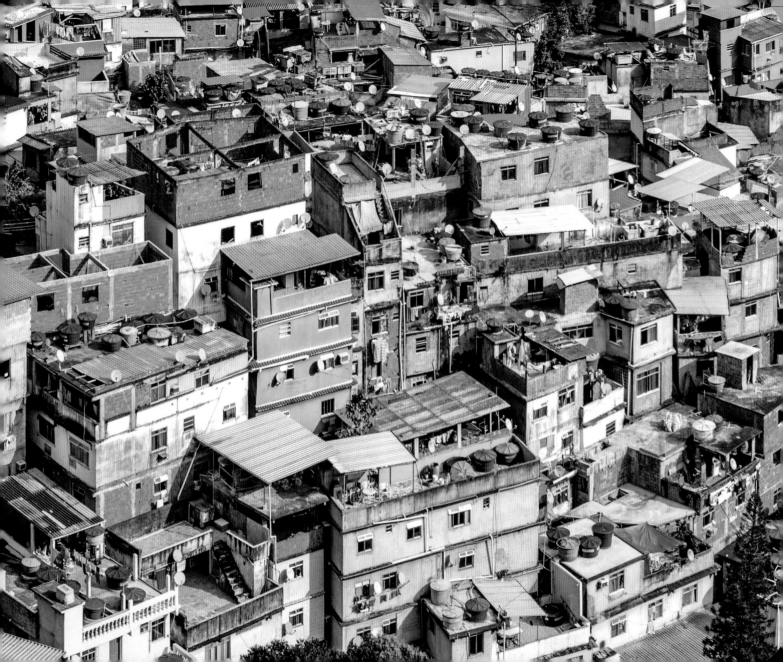

DJEMAA EL FNA SQUARE, MARRAKESH, MOROCCO

As dusk falls, this historic square comes alive with activity. There are acrobats, musicians, snake charmers, and fortune-tellers. Water sellers with fringed hats clang brass cups together to attract customers, and the smell of freshly cooked food fills the air. The perfect place for an evening stroll!

See if you can spot…

A camera

7 motobikes

2 horses

5 orange stools

4 monkeys

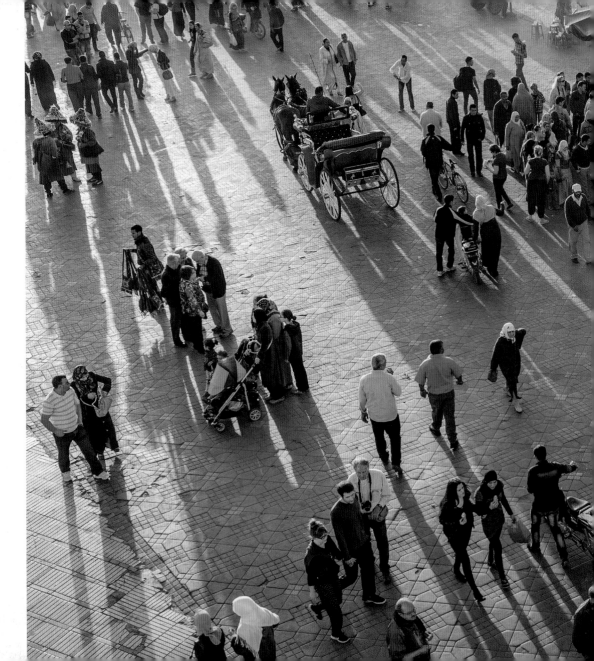

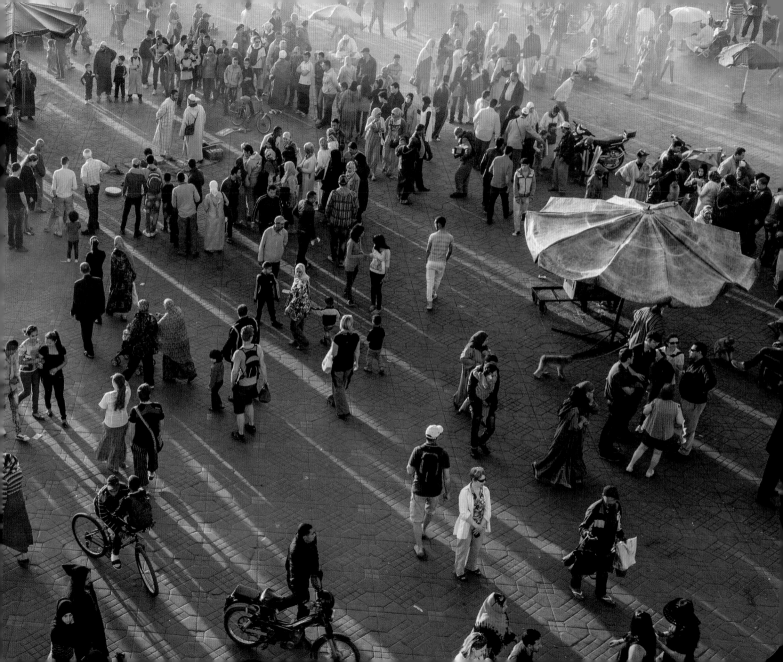

DRAGON BOAT FESTIVAL, HONG KONG, CHINA

According to legend, long ago, a famous poet, Qu Yuan, drowned in the Miluo River. Locals paddled out to his rescue, throwing balls of rice into the water to stop the river creatures from feasting on his body. Today, teams race each other in 'dragon boats' and bang drums to scare away evil spirits.

See if you can spot...

41

The number 41

A pink scarf

An anchor symbol

A (hidden) dragon

2 white-and-green parasols

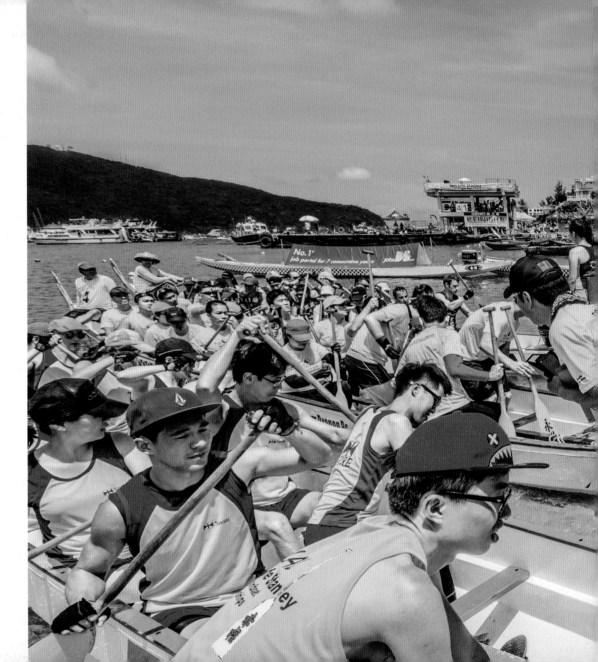

SYDNEY TO HOBART YACHT RACE, AUSTRALIA

This annual event is the world's toughest open-ocean sailing race. There are no lanes or signposts to show the way, and conditions can get pretty wild with gale-force winds and huge waves. At other times, the waters are so calm and flat that the boats struggle to move at all!

See if you can spot...

1 yellow lifeguard buoy

6 orange lifeguard buoys

150

The number 150

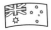

An Australian flag

A skull and crossbones

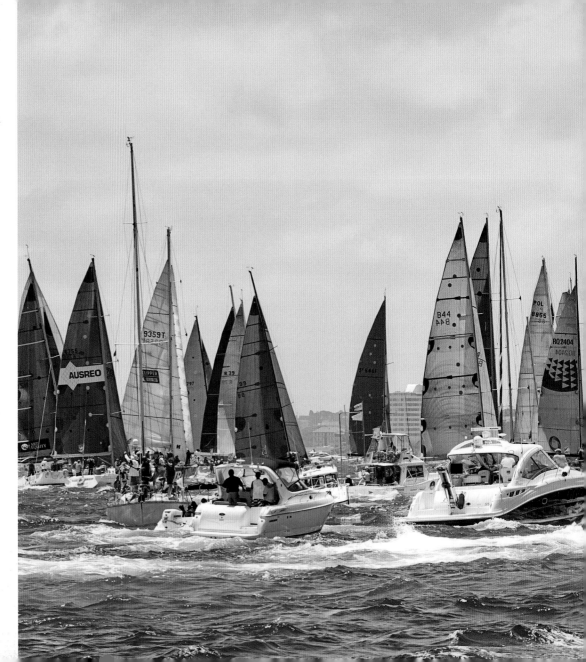

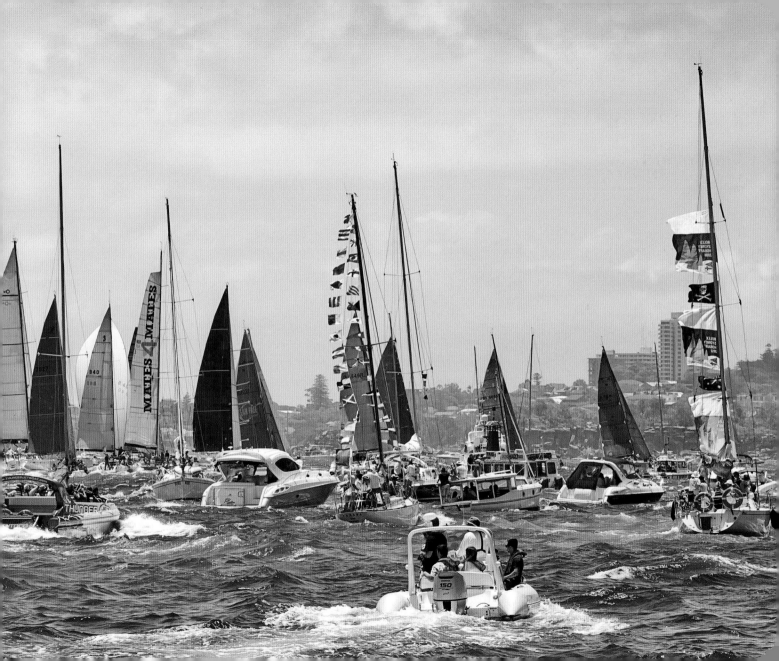

ANSWERS

Balloon Festival, Albuquerque, USA – p.6

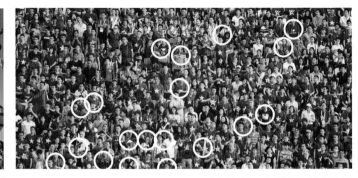

The National Stadium, Singapore – p.8

Shibuya Center-Gai, Tokyo, Japan – p.10

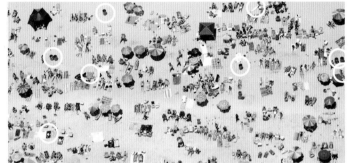

Wrightsville Beach, N. Carolina, USA – p.12

El Encants Vells, Barcelona, Spain – p.14

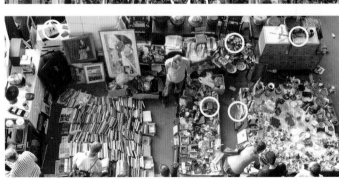

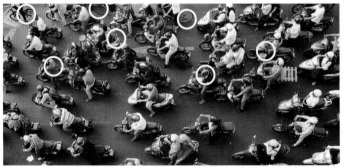

Ho Chi Minh City, Vietnam – p.16

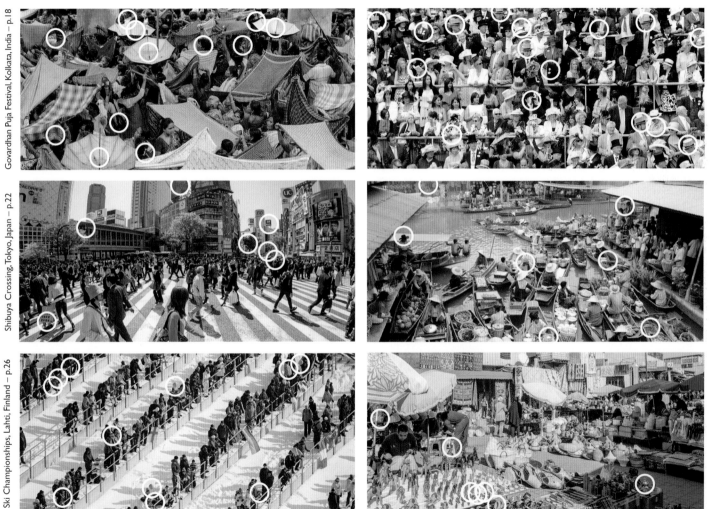

Govardhan Puja Festival, Kolkata, India – p.18

Royal Ascot, Berkshire, UK – p.20

Shibuya Crossing, Tokyo, Japan – p.22

Floating Market, Amphawa, Thailand – p.24

Ski Championships, Lahti, Finland – p.26

Souk District, Marrakesh, Morocco – p.28

59

ANSWERS

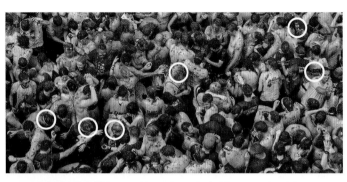

Tomatina Festival, Buñol, Spain – p.30

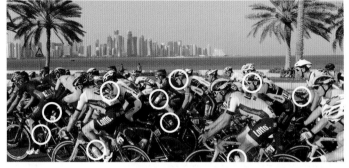

Tour of Qatar, Doha, Qatar – p.32

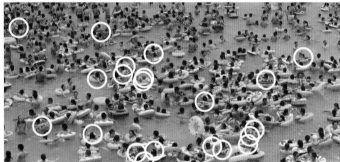

Dead Sea Resort, Suining, China – p.34

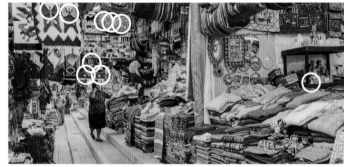

Souvenir shops, Cuzco, Peru – p.36

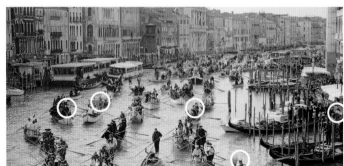

Carnival, Venice, Italy – p.38

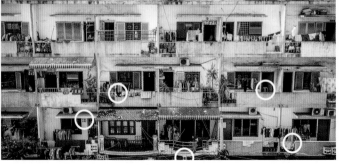

Apartment, Phnom Penh, Cambodia – p.40

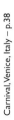

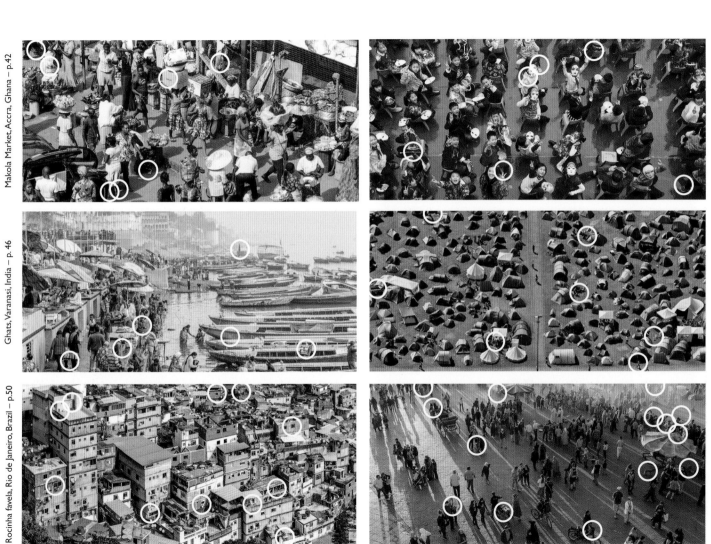

Makola Market, Accra, Ghana – p.42

Lantern Festival, Guangzhou, China – p.44

Ghats, Varanasi, India – p. 46

Campsite, Munich, Germany – p. 48

Rocinha favela, Rio de Janeiro, Brazil – p.50

Djemaa El Fna, Marrakesh, Morocco – p. 52

ANSWERS

Dragon boats, Hong Kong, China – p.54

Sydney–Hobart Yacht Race, Australia – p. 56

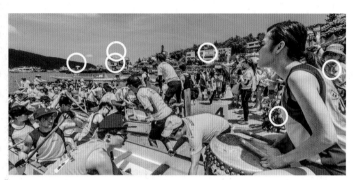

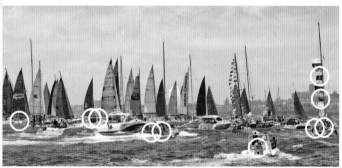

CREDITS